The LOVECRAFT colouring book

20 original macabre illustrations by

DS BLAKE

ISBN 978-1-326-83536-1

FIRST EDITION 2016
Copyright © Idle Toil 2016

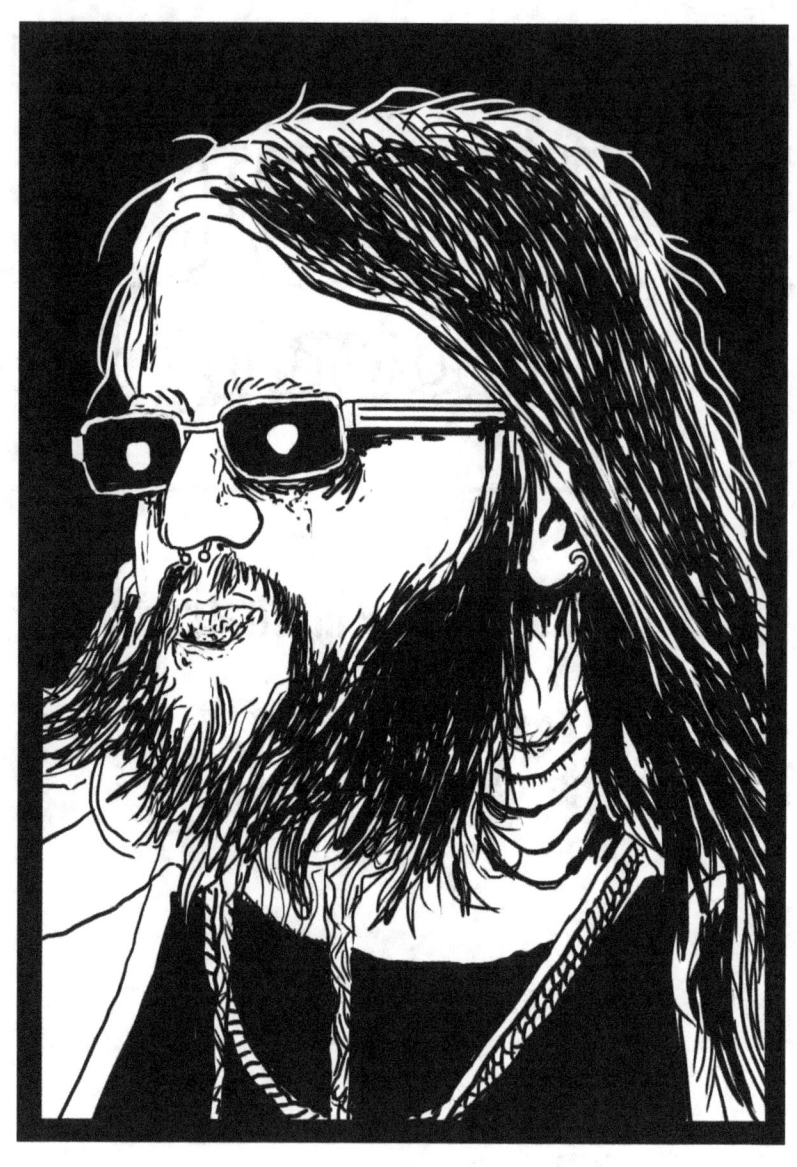

For N, as always.

And HPL, with some key reservations.

WARNING! THIS BOOK CONTAINS SOME IMAGES OF A MACABRE AND/OR VIOLENT NATURE AND IS RECOMMENDED FOR ADULTS ONLY

Please Note: Each image has a blank spread seperating it from each other image. This is to allow you to use pens and other colouring media that might bleed through or smudge without having to worry about damaging other images. No pages are missing from this book.

Follow on Twitter:
@SimonCardew

DS Blake on deviantart:
DSblake.deviantart.com

Support on Patreon:
patreon.com/IdleToil

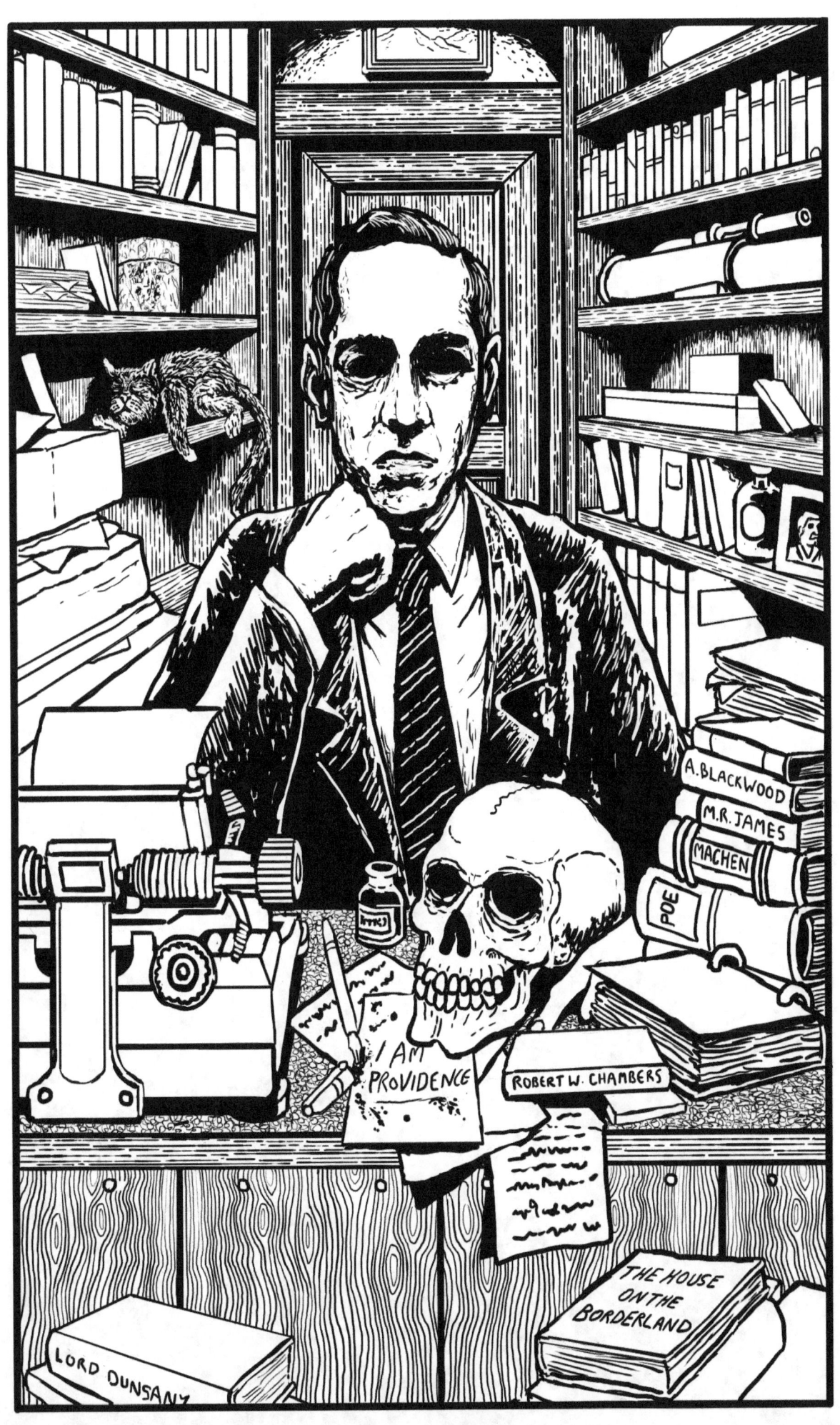

I: The Old Man of Providence

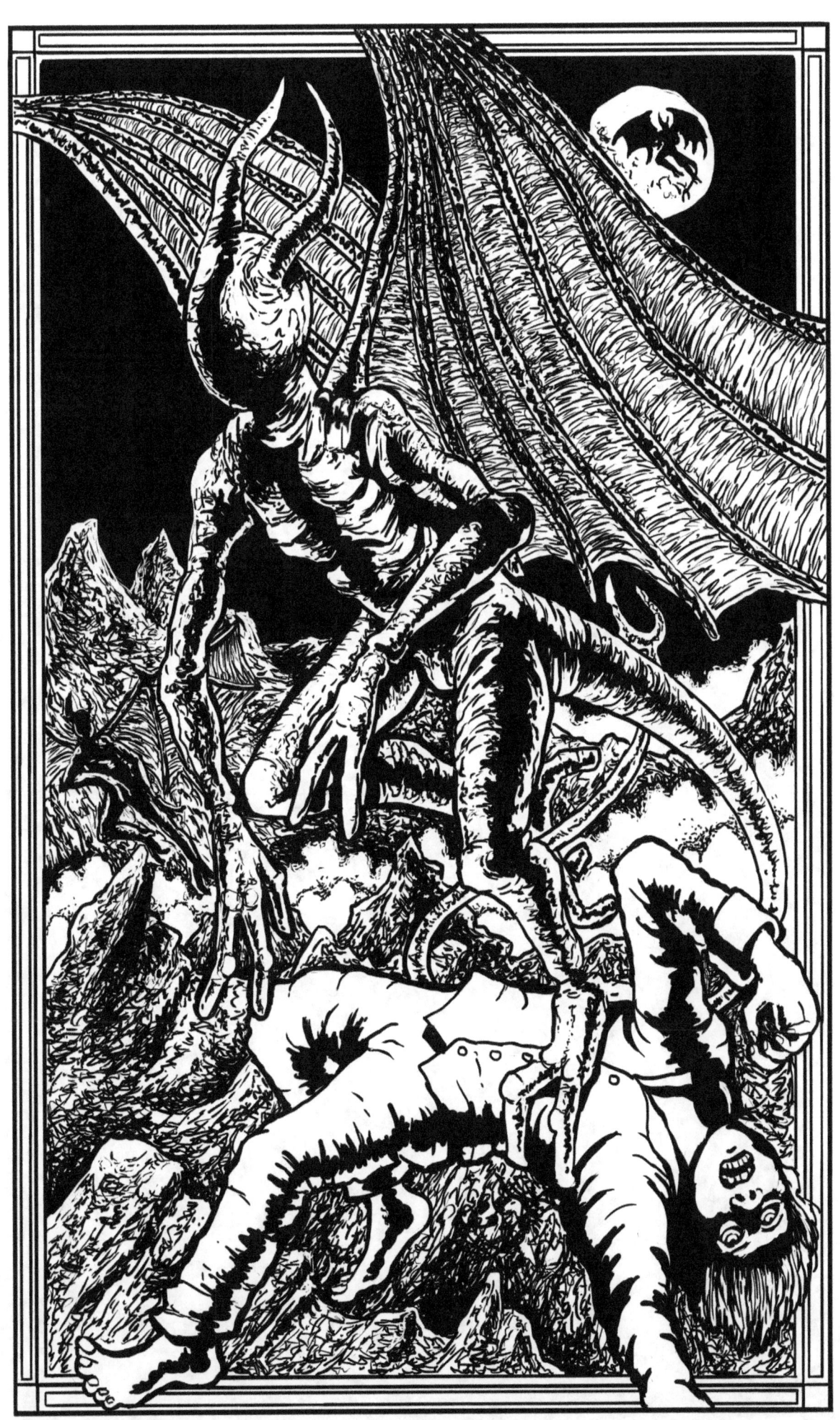

II: Night-Gaunts

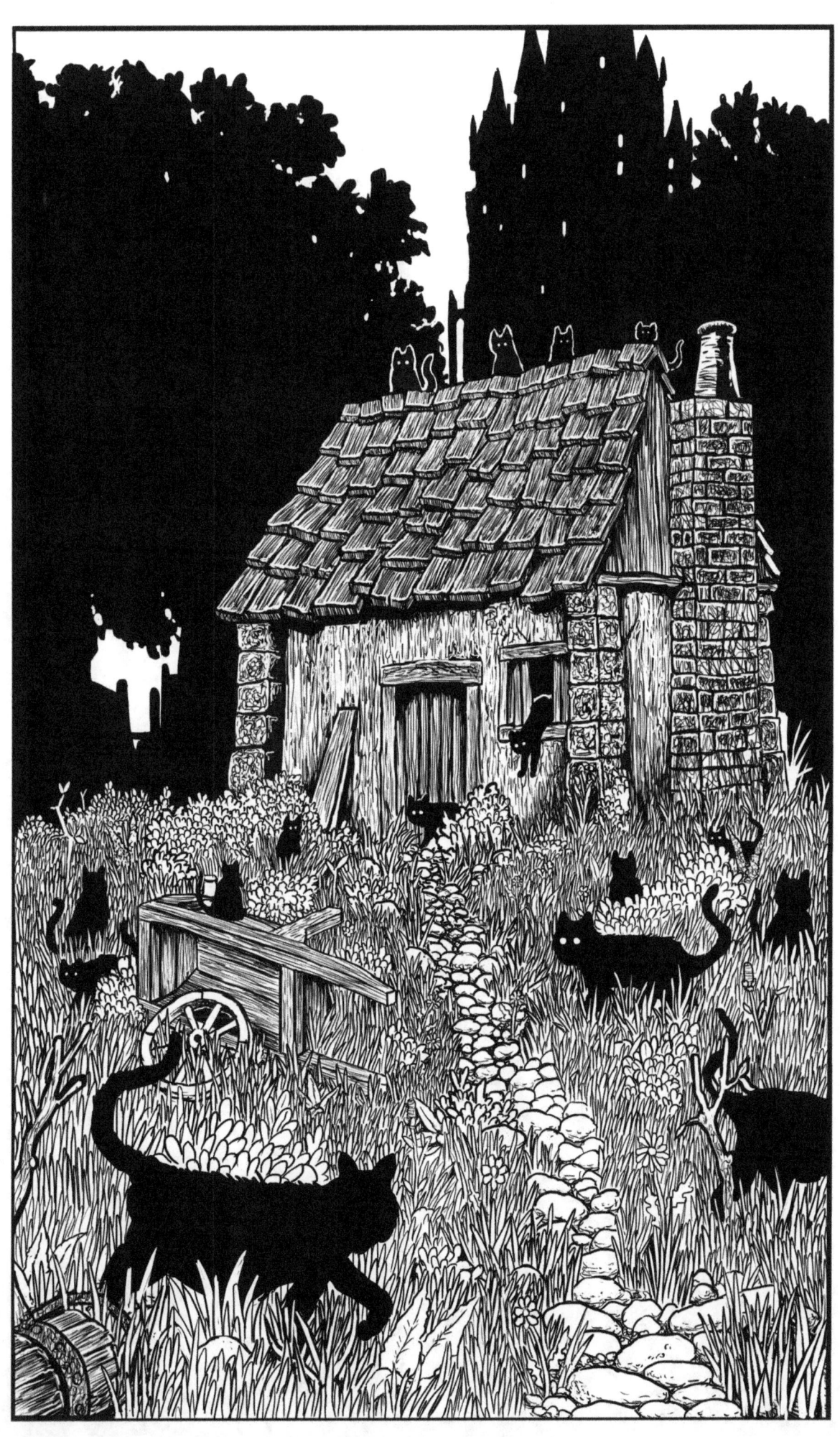

III: The Cats of Ulthar

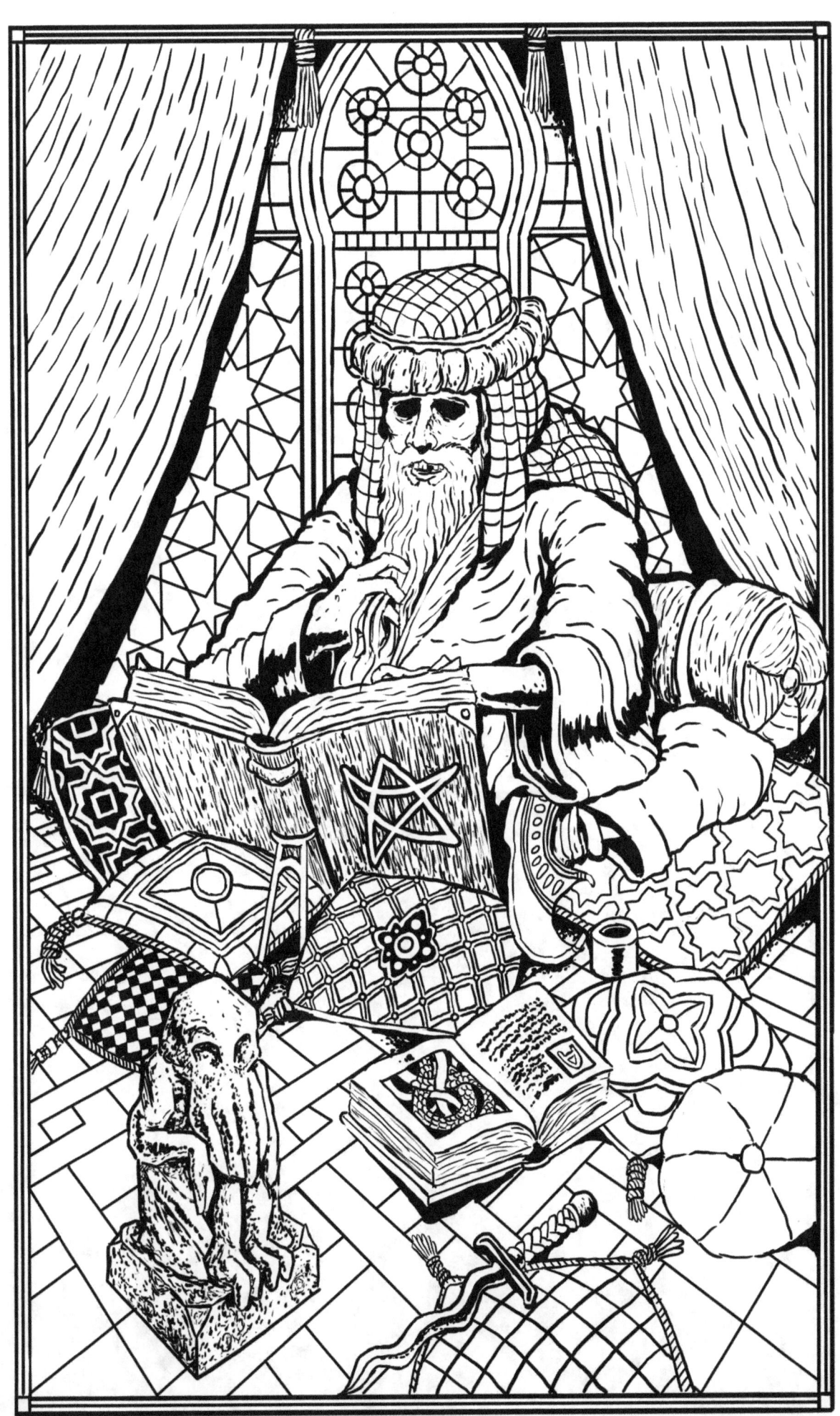

IV: Abdul Alhazred

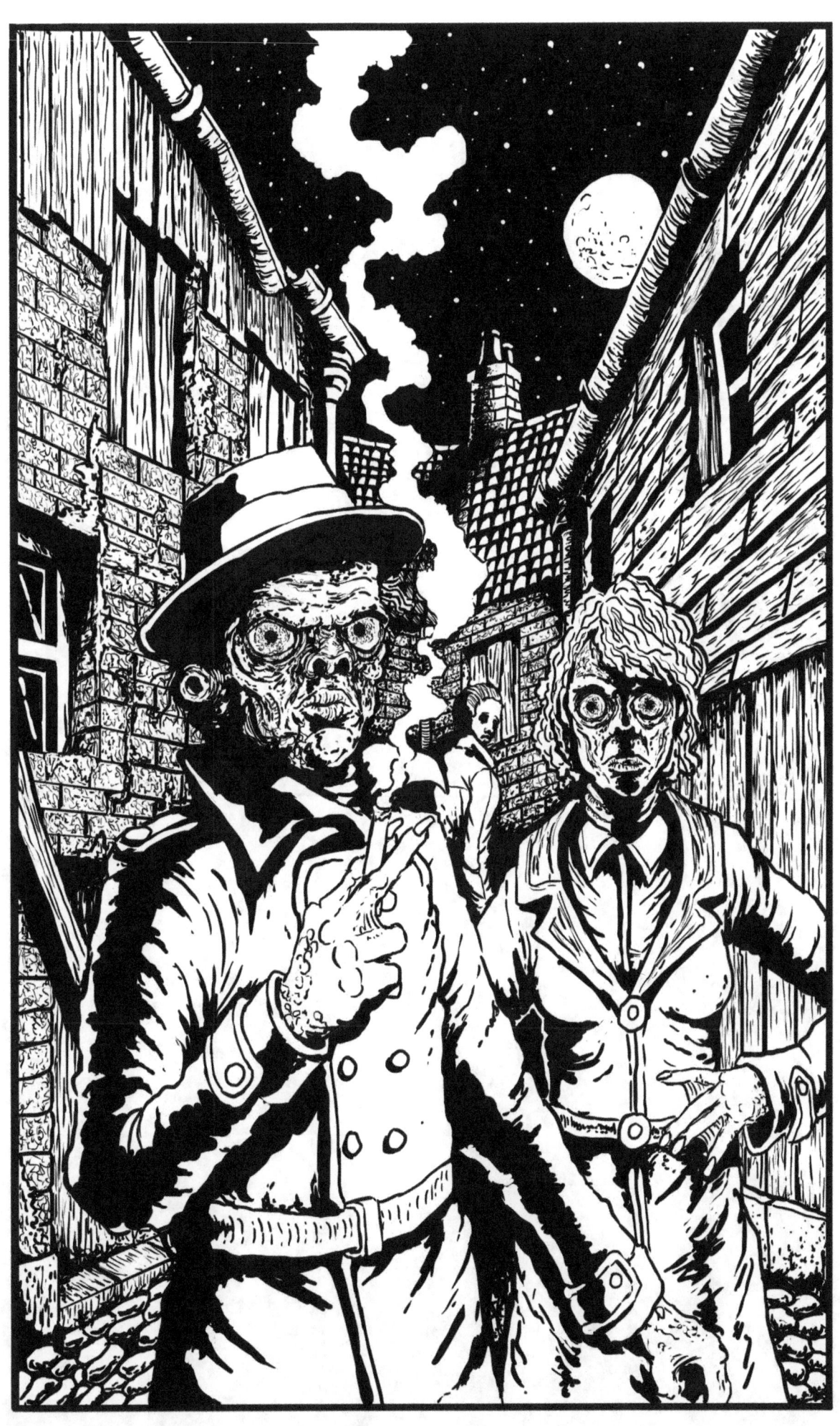
V: The Innsmouth Look

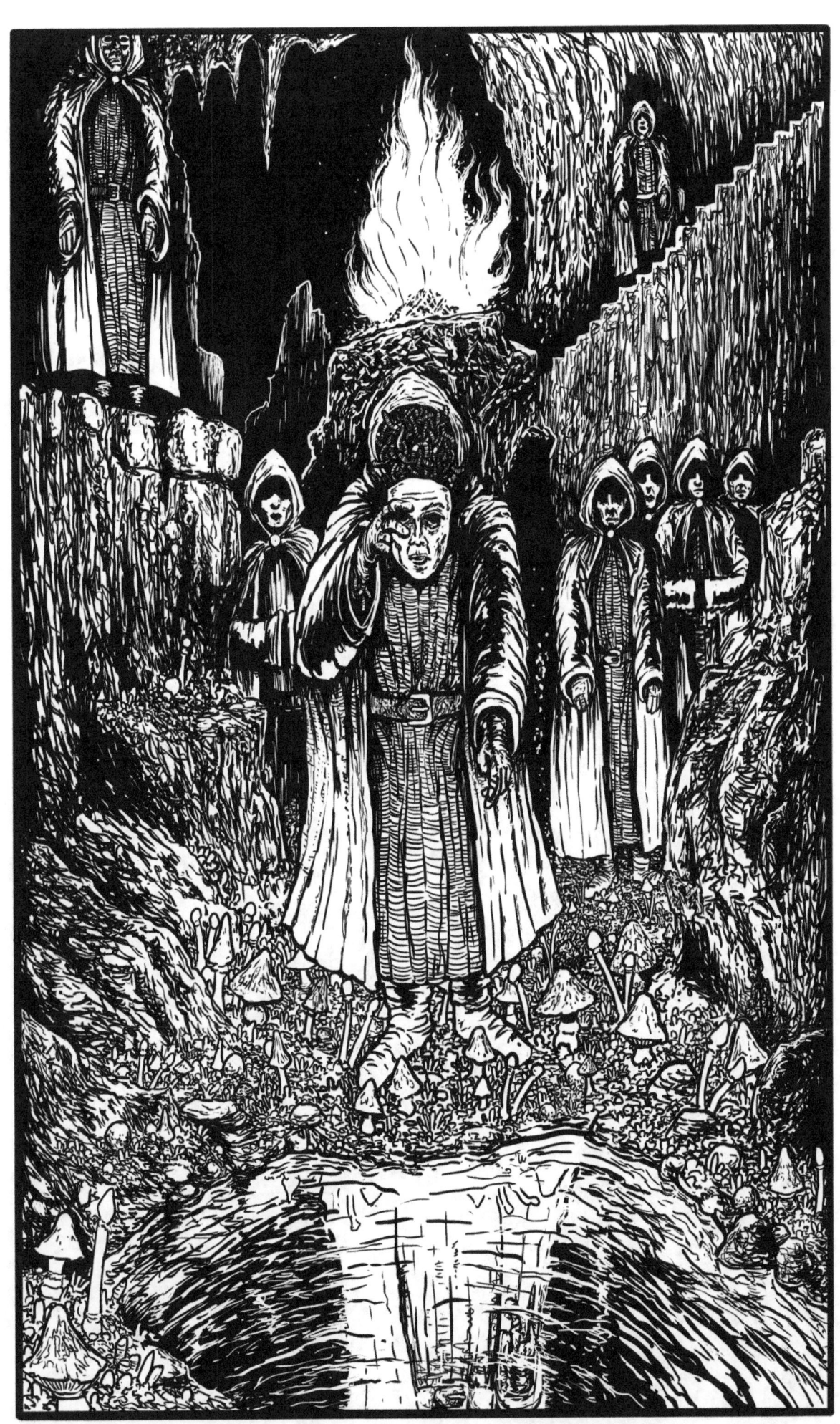

VI: Things Have Learnt to Walk...

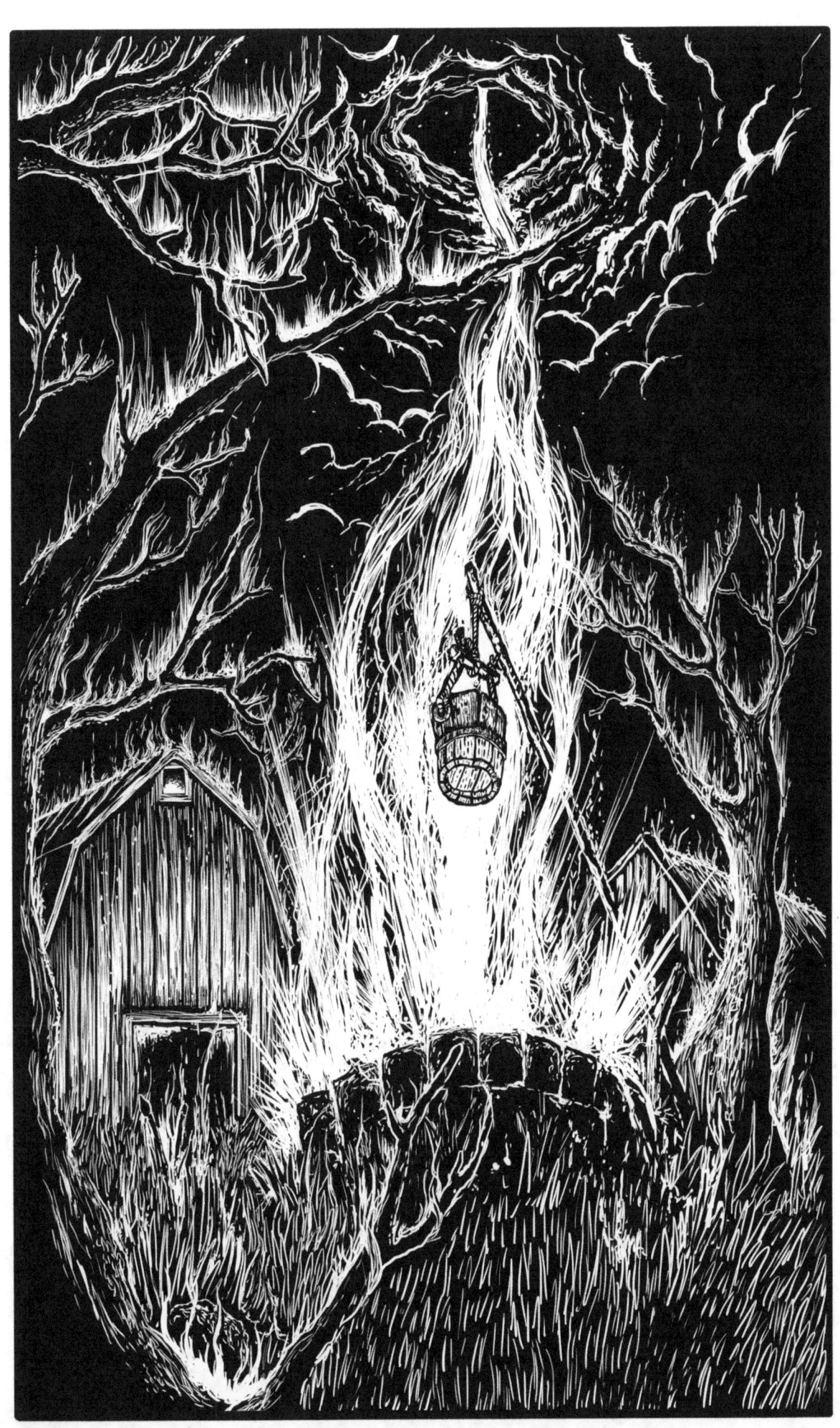

VII: The Colour Out of Space

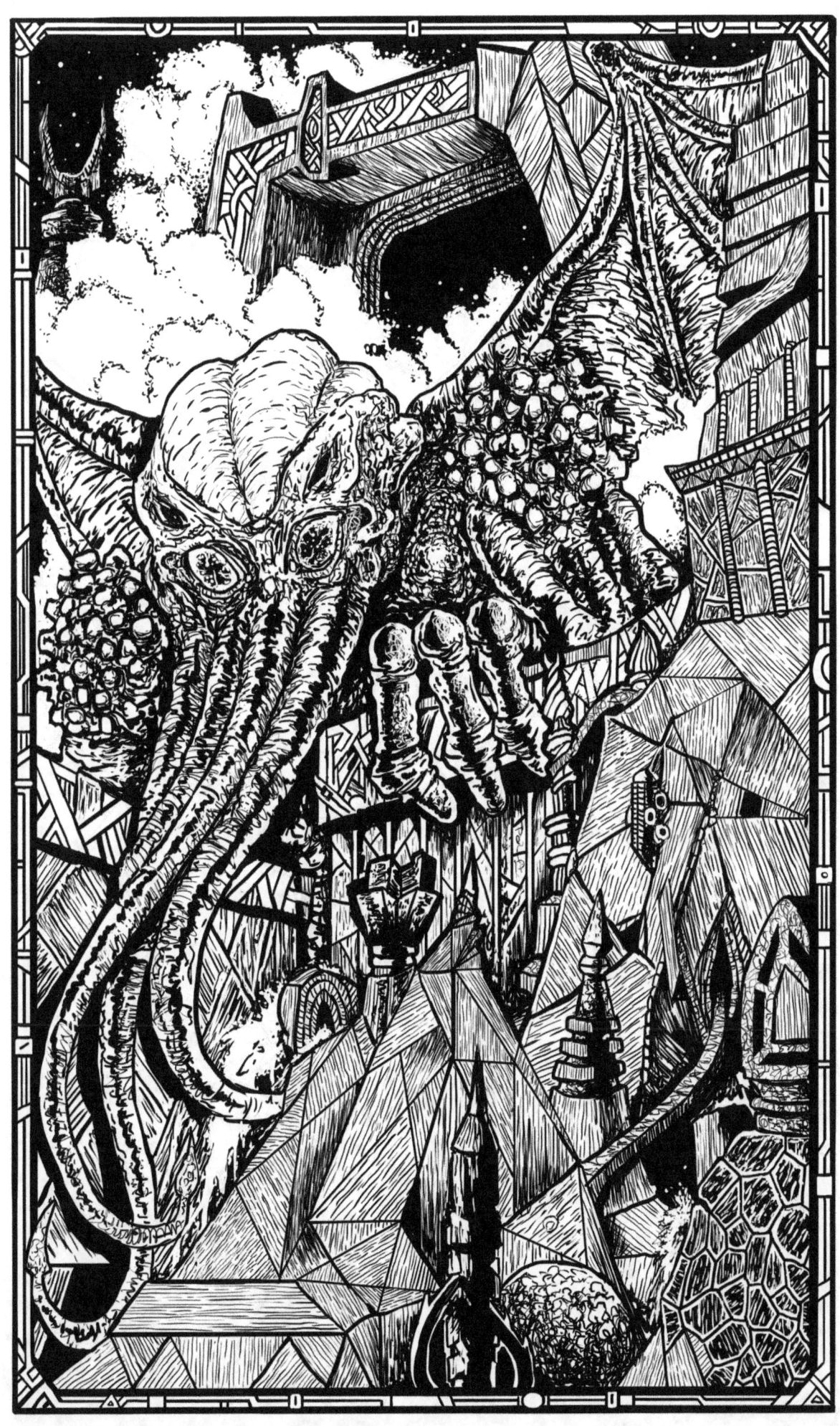

VIII: Cthulhu Wakes

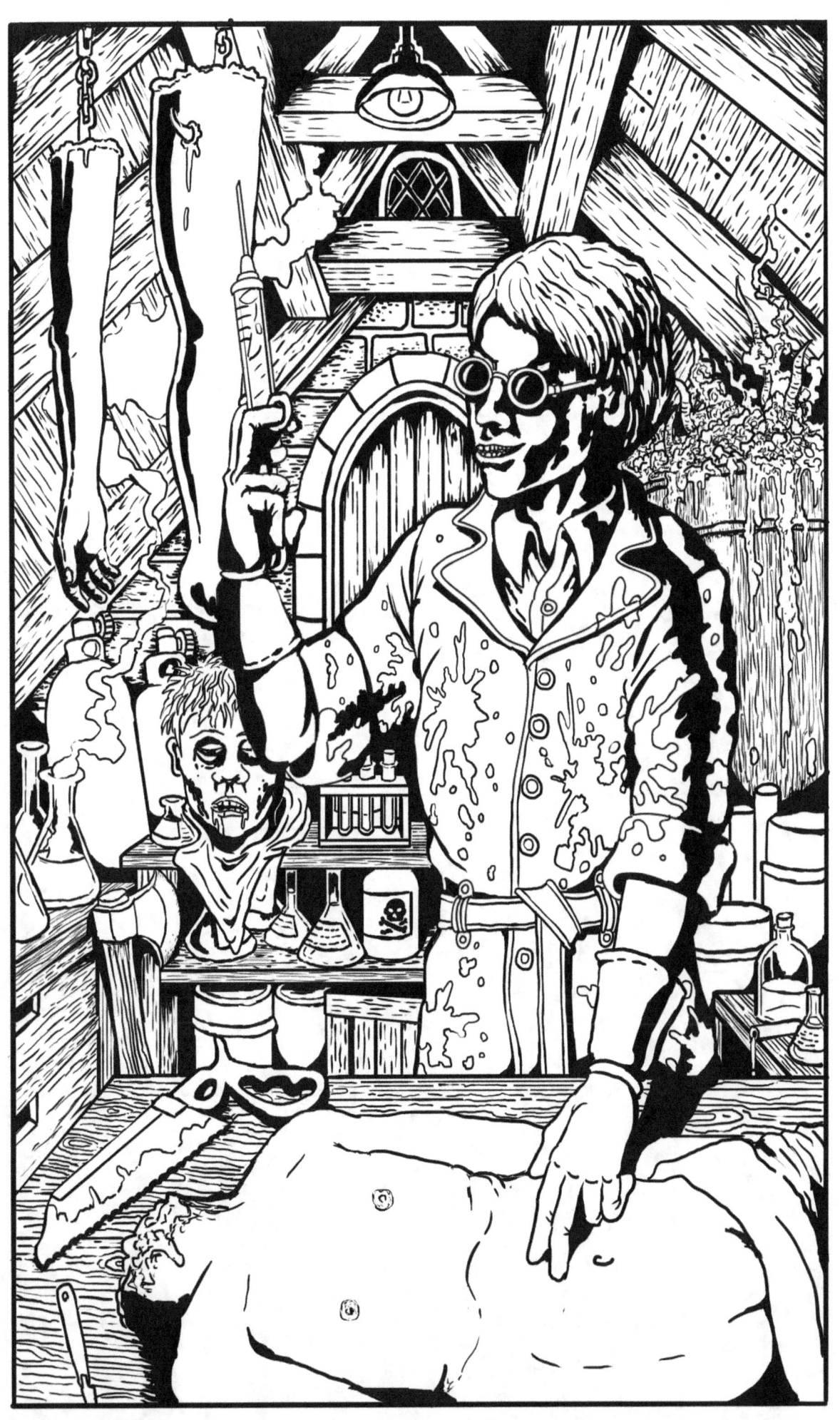

IX: Herbert West - Reanimator

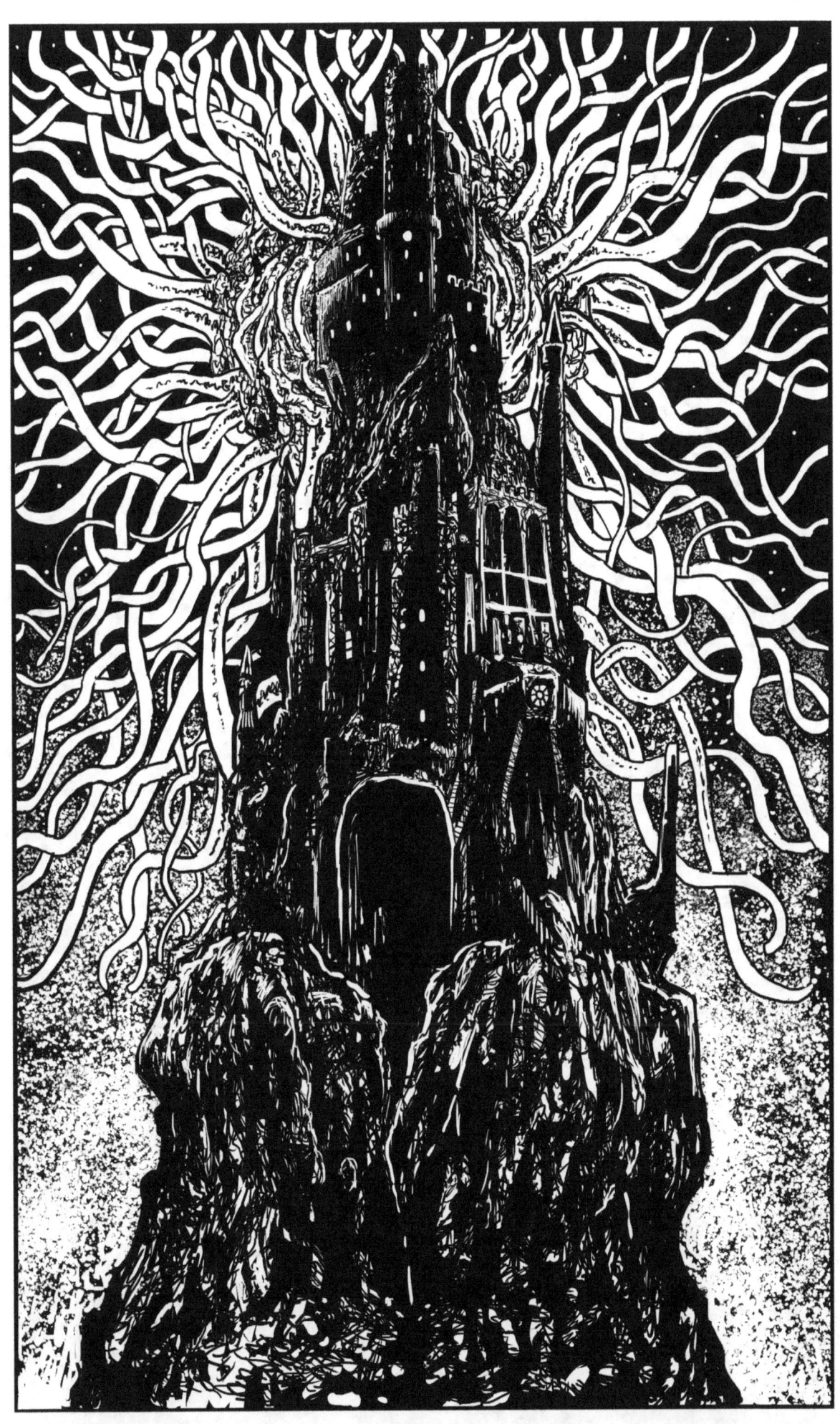

X: The Unknown Kadath in the Cold Waste

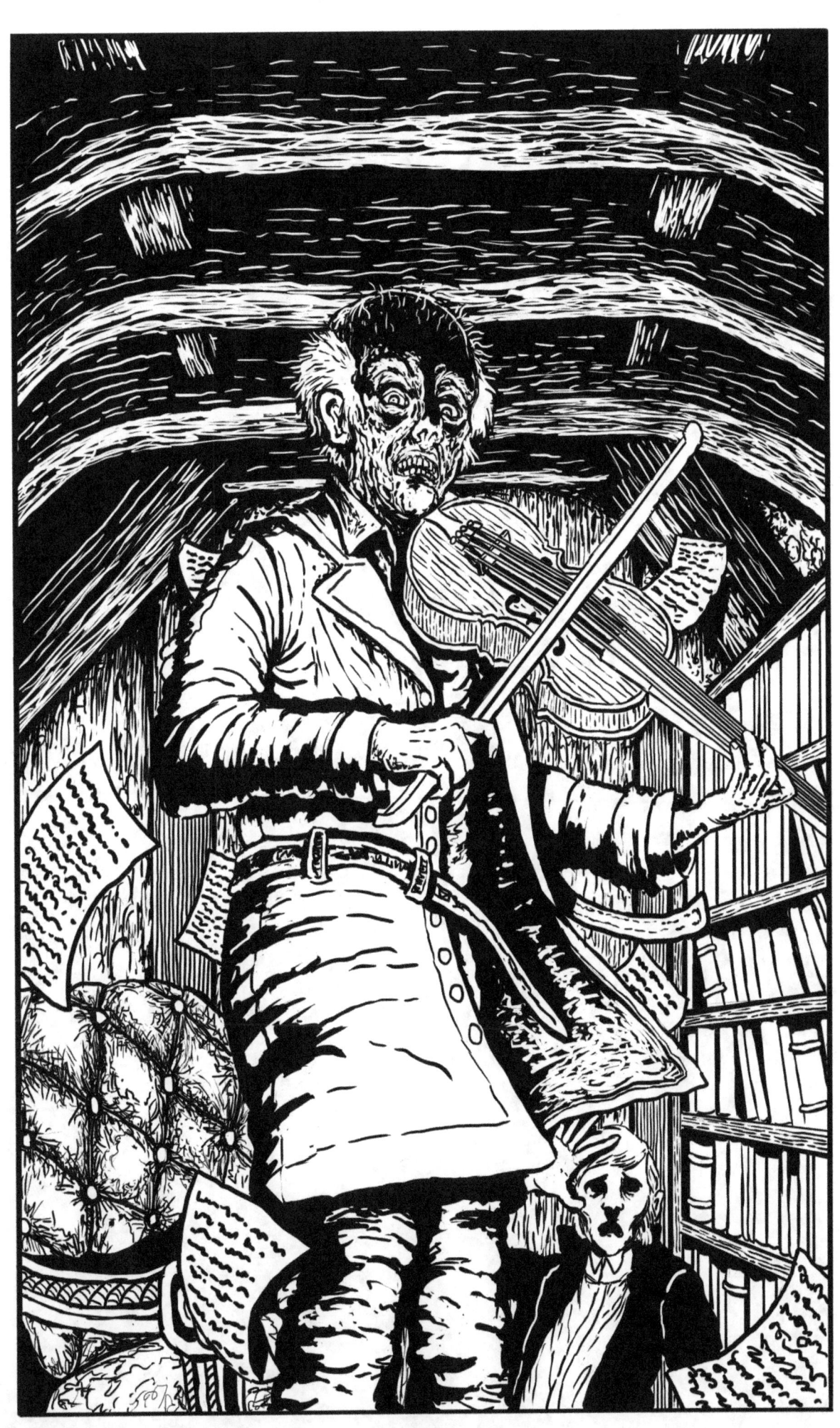

XI: The Music of Erich Zann

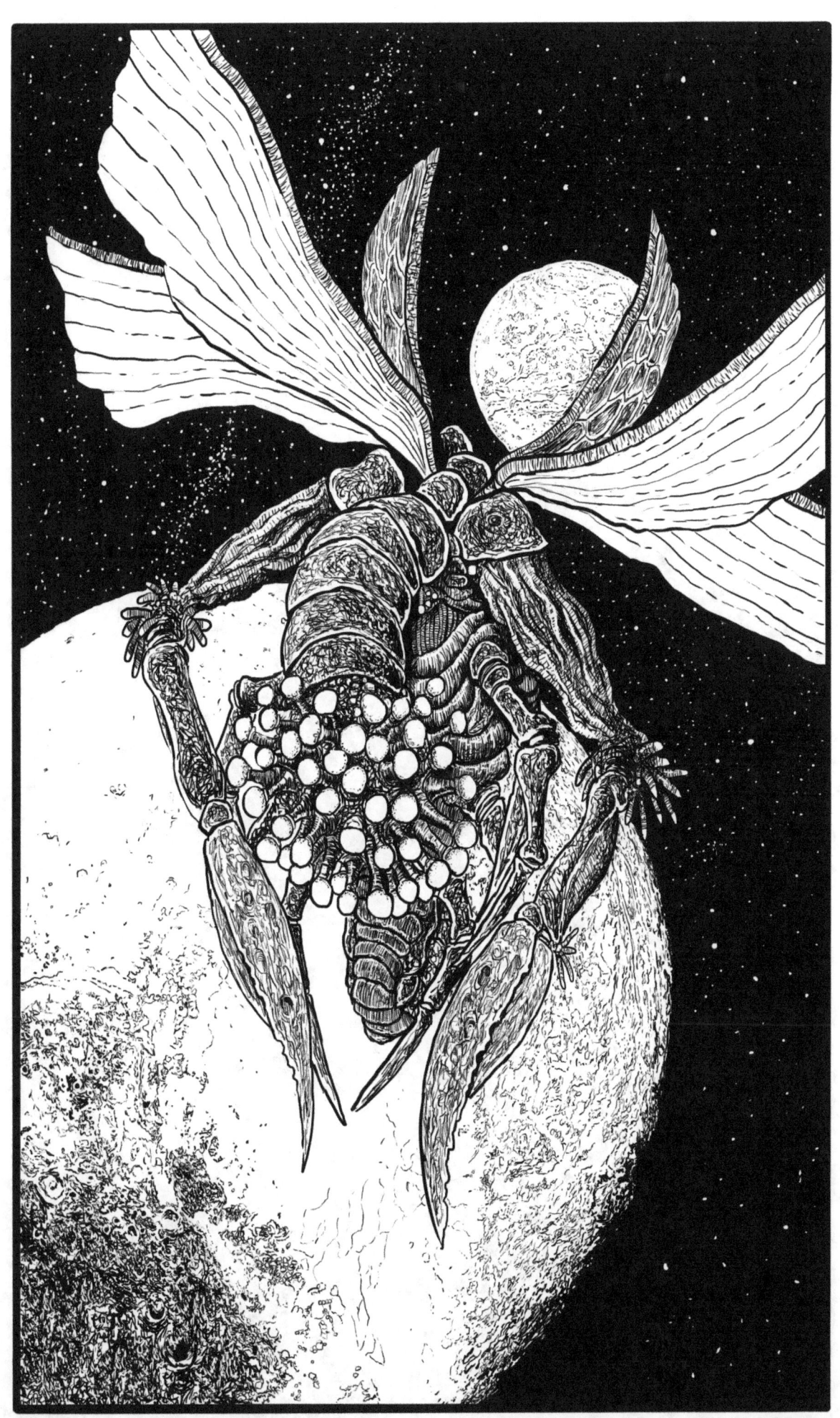

XII: Fungi From Yuggoth

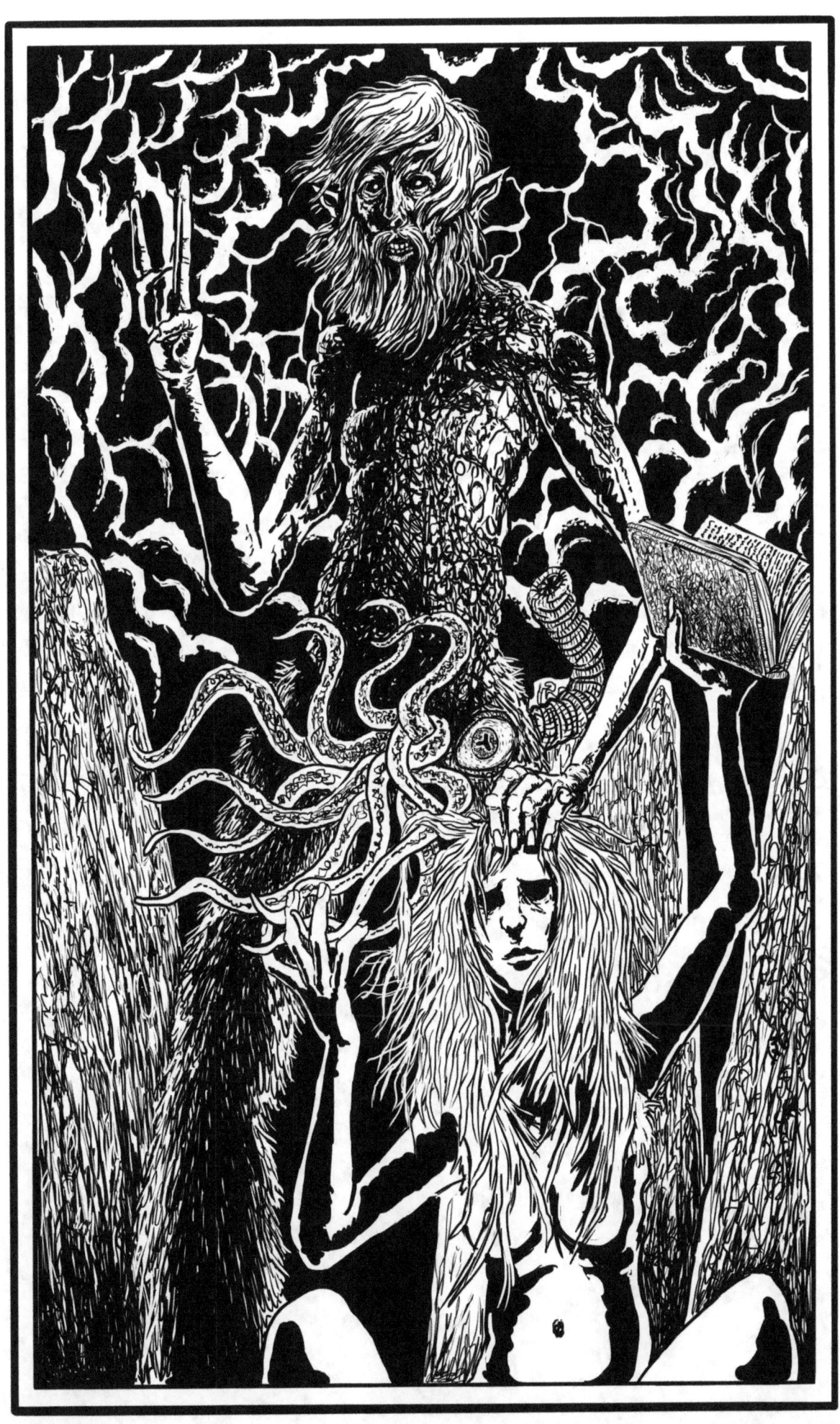

XIII: Lavinia and her Brat

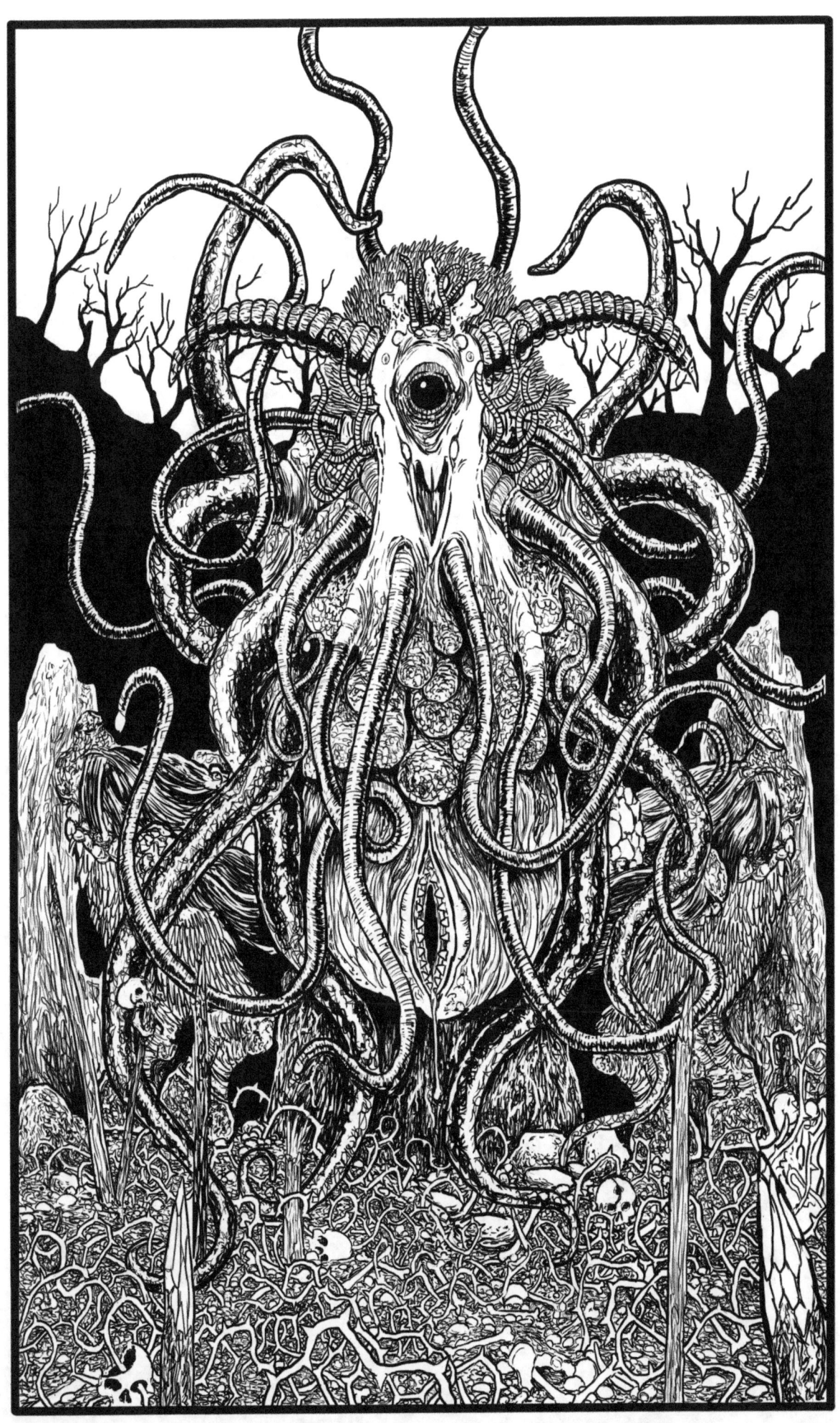

XIV: The Black Goat of the Woods

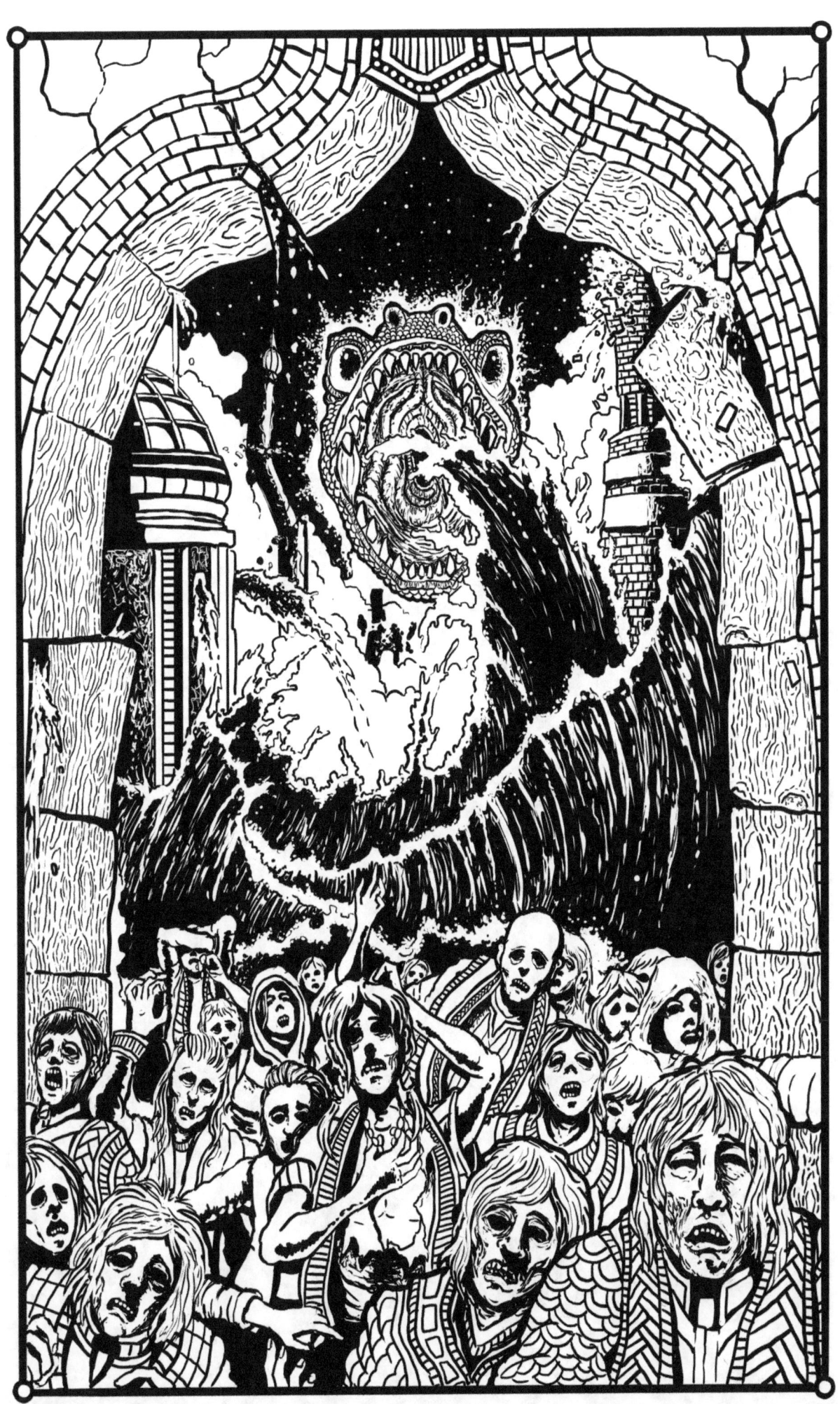

XV: The Doom that Came to Sarnath

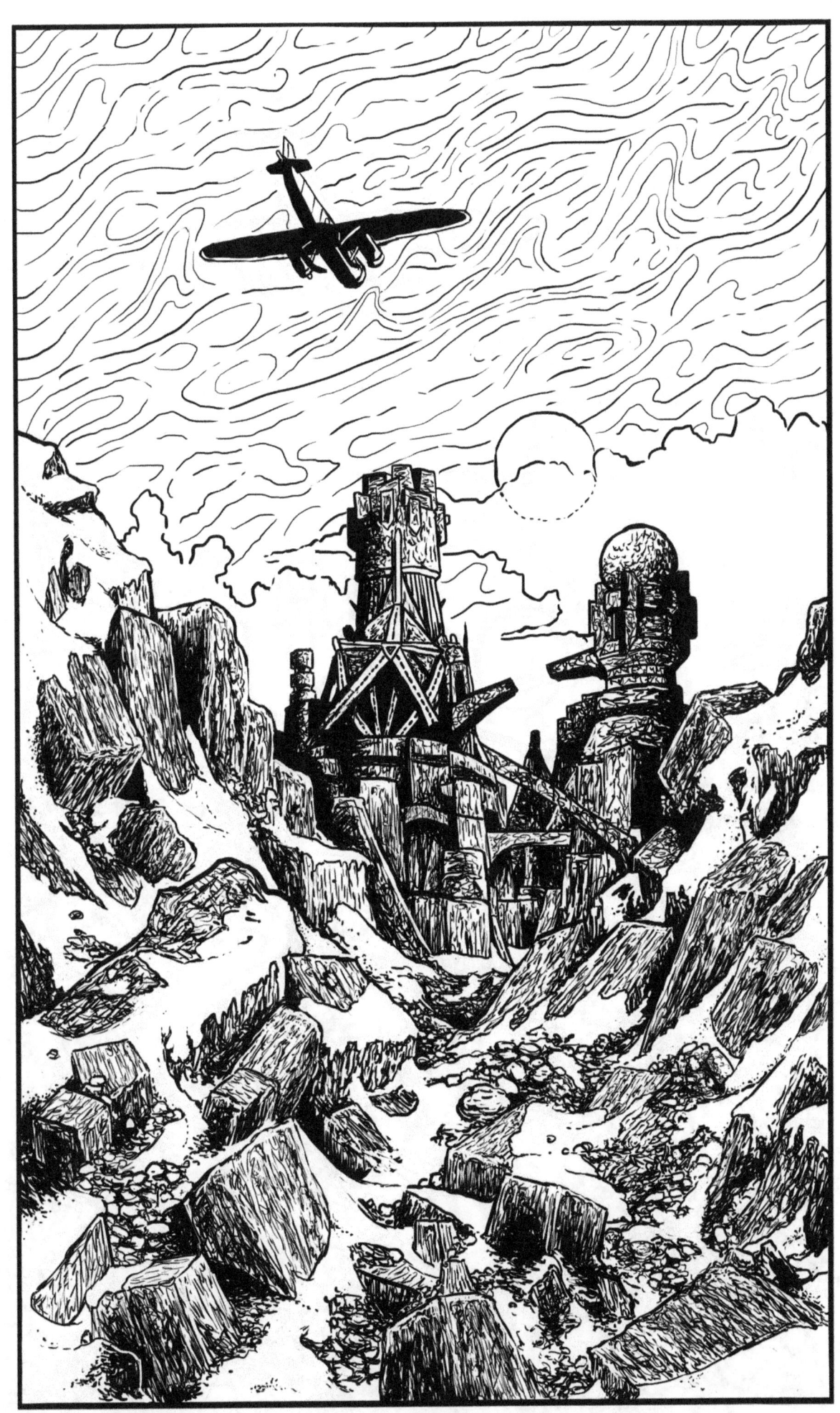

XVI: At the Mountains of Madness

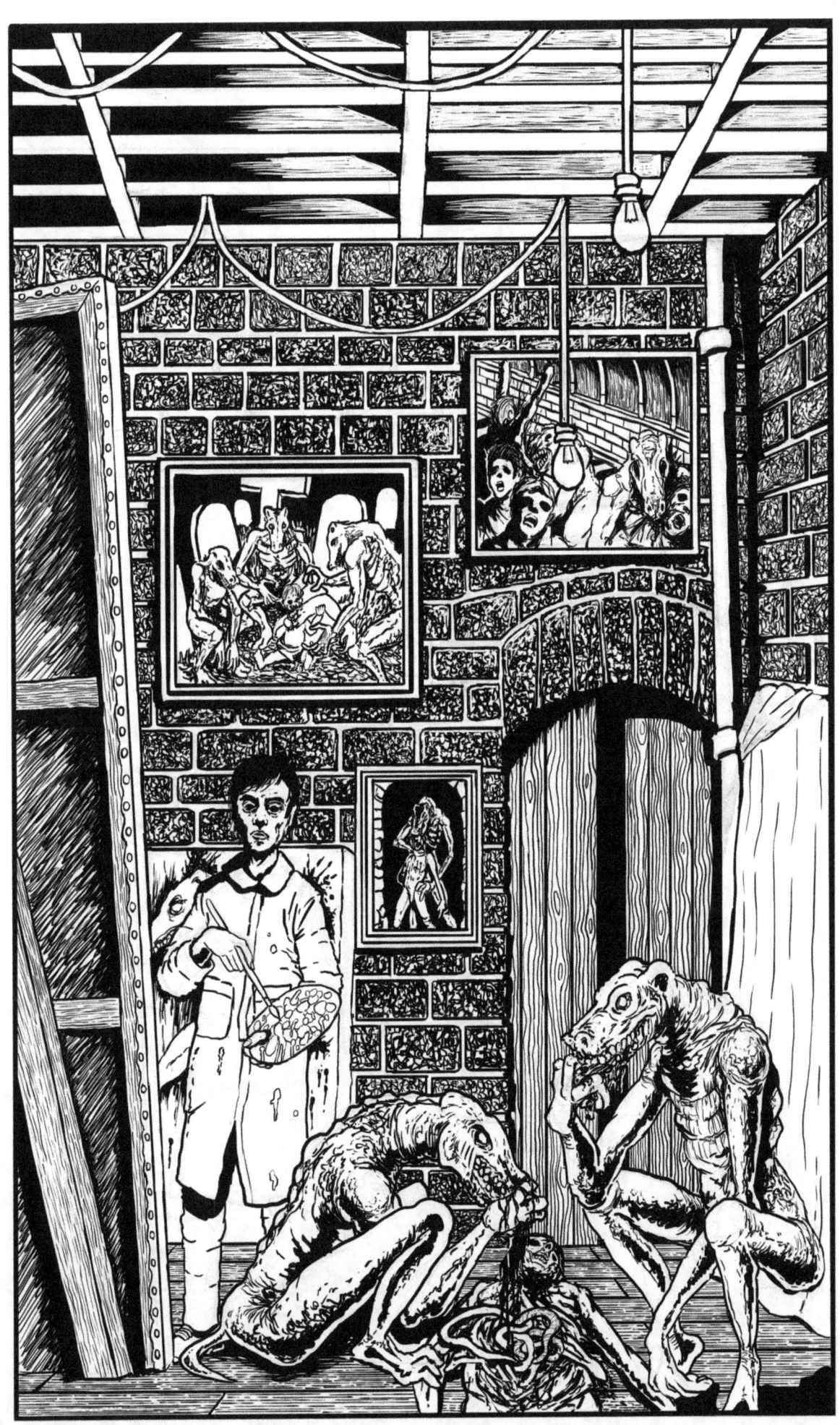

XVII: Pickman's Model

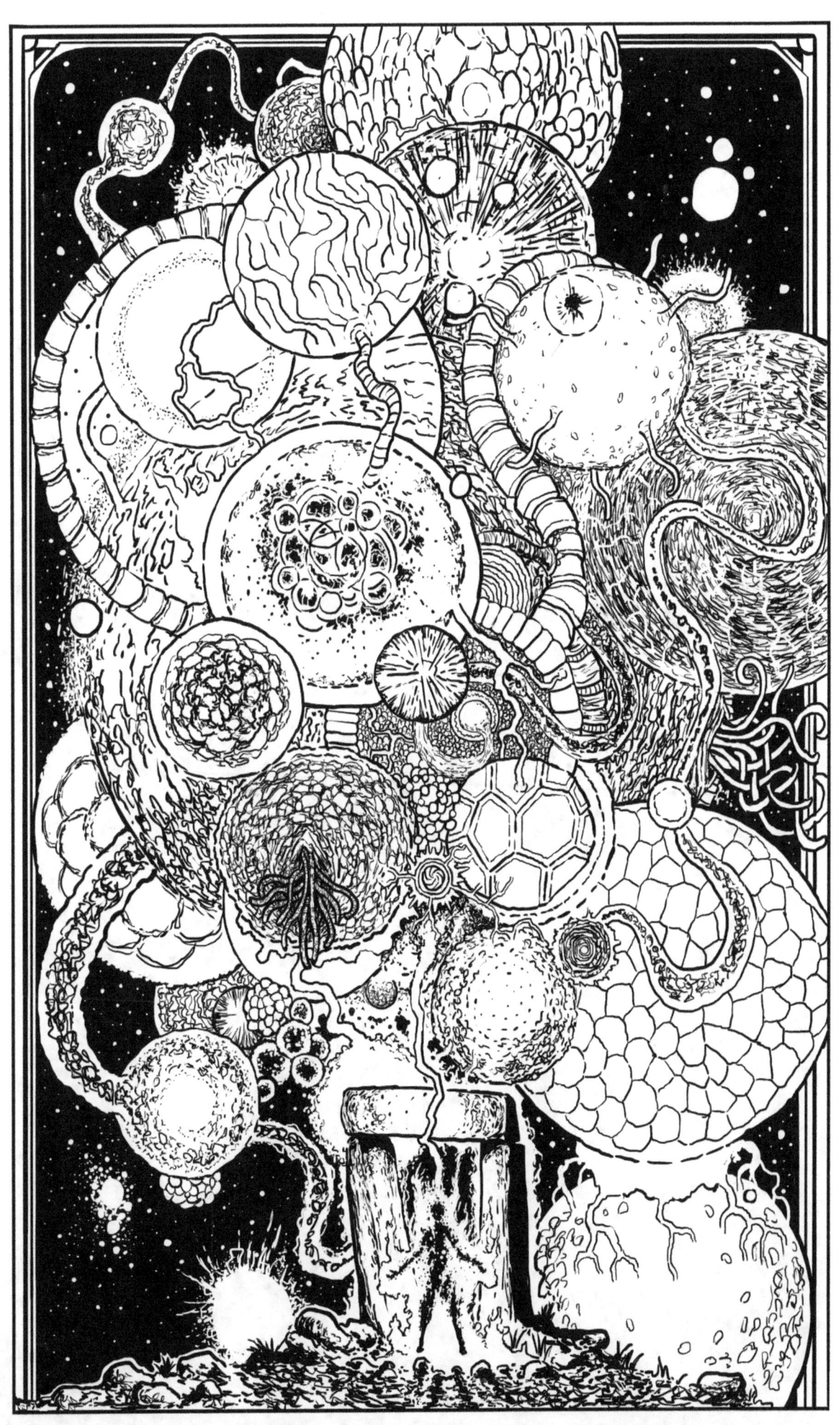

XVIII: The Gate, and the Key to the Gate

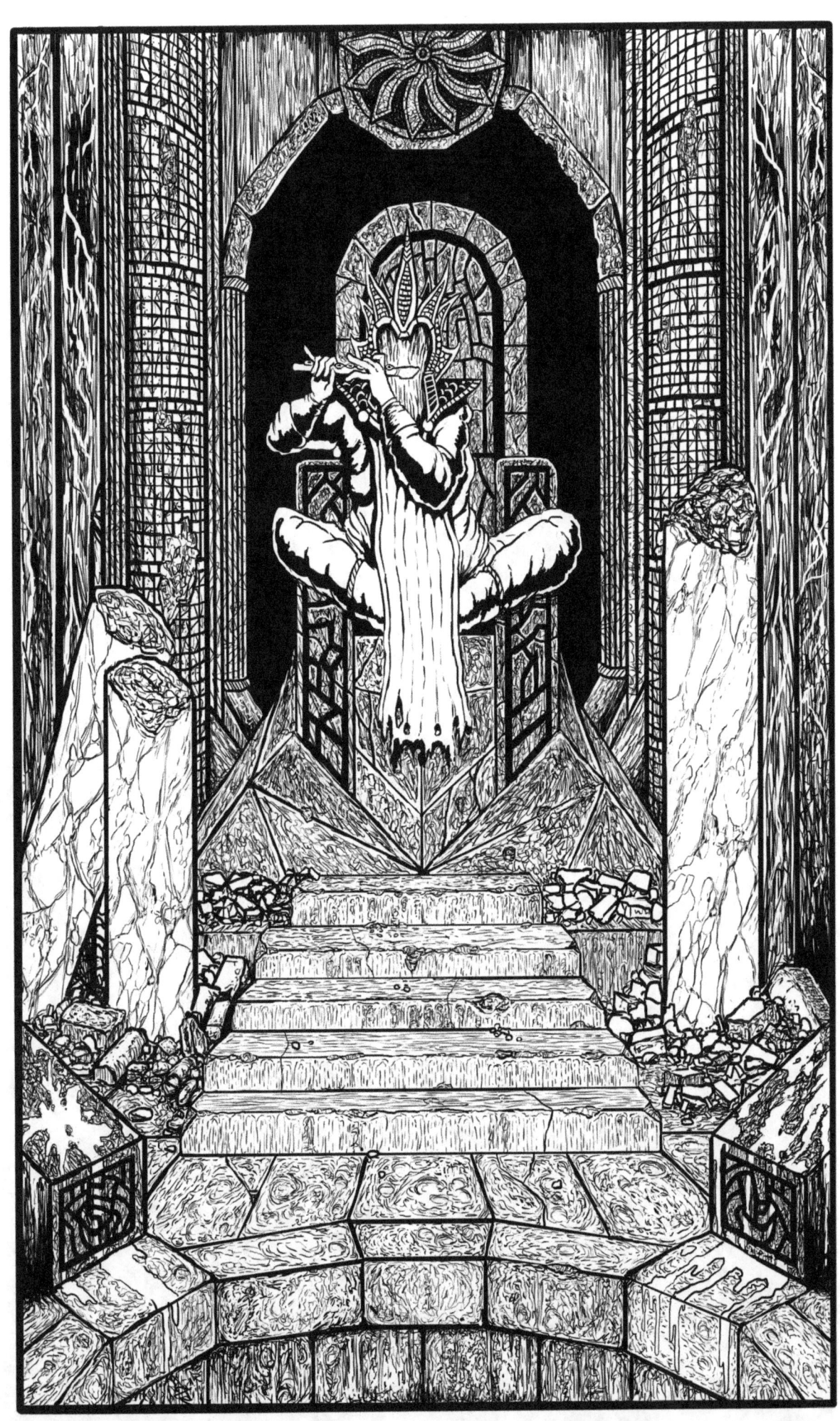

XIX: The High Priest Not-to-be-Described

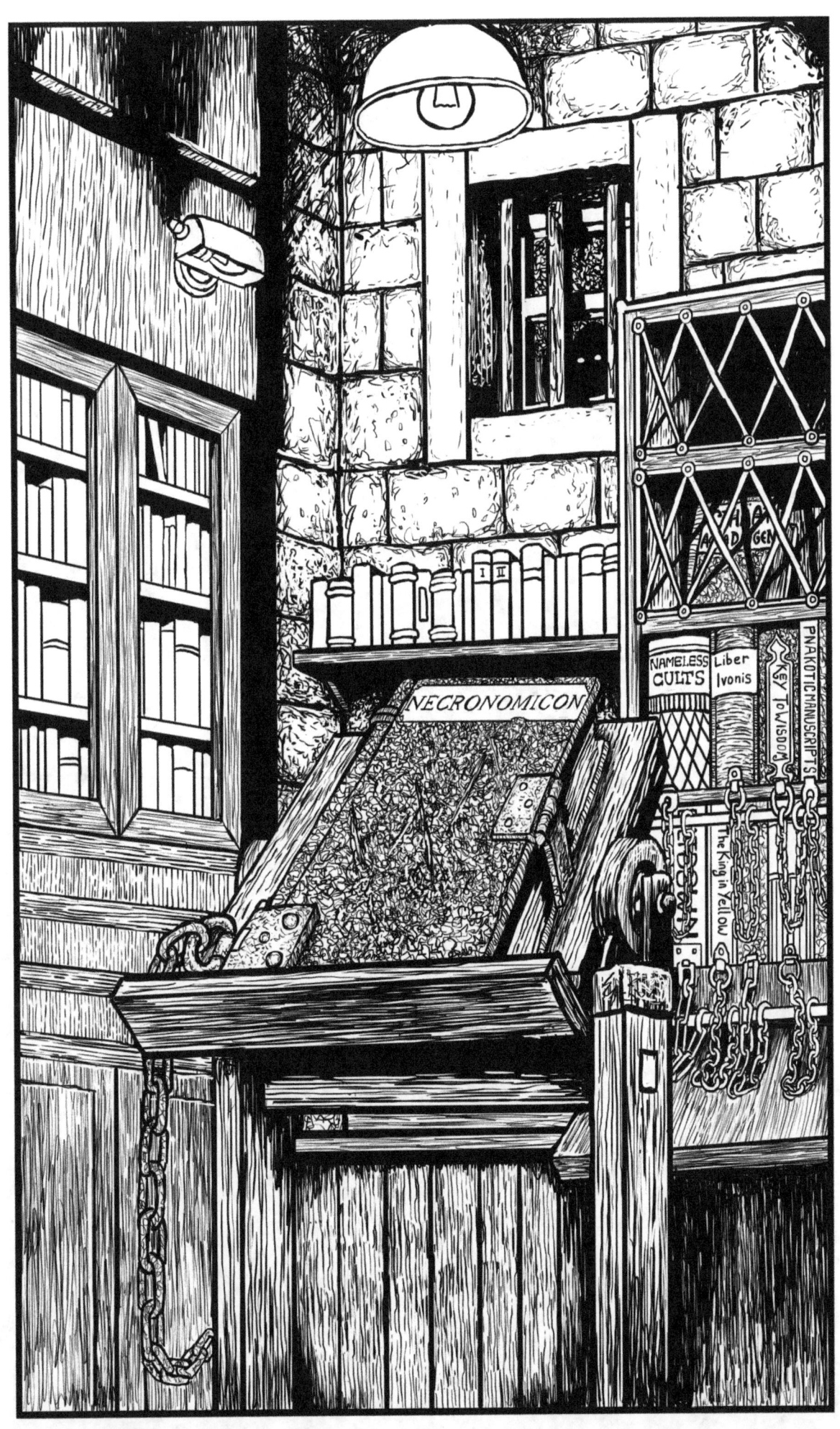

XX: The Rare Book Room

Other Titles from Idle Toil Press:

Available via lulu.com, amazon.com and other leading online booksellers.

By DS Blake:
Illustration and Cartoons

The Glimmercage Urists, or A Catalogue of Dwarven Calamities: A Dwarf Fortress book
ISBN: 978-1291674828

Bowel Movements: Modern Art History on the Lavatory
ISBN: 978-1326349653

The Occult Colouring Book
ISBN: 978-1326505752

The Cyberpunk Colouring Book
ISBN: 978-1326650711

By Simon Cardew:
Artist's Books

Exonomnicon
ISBN: 978-1291341720

Manifest-O
ISBN: 978-1291341683

Vectis
ISBN: 978-1291371314

Utopia/Dystopia
ISBN: 978-1291536034

Speak of the Devil
ISBN: 978-1291680300

16 Landscapes
ISBN: 978-1291893854

Physical Remains
ISBN: 978-1326252137

www.ingramcontent.com/pod-product-compliance
Lightning Source LLC
Chambersburg PA
CBHW081049170526
45158CB00006B/1907